SECRETS FROM THE CENTER OF THE WORLD

JOY HARJO | PHOTOGRAPHS BY STEPHEN STROM

Secrets from the Center of the World

THE UNIVERSITY OF
ARIZONA PRESS

TUCSON

The University of Arizona Press
www.uapress.arizona.edu

Copyright © 1989 by The Arizona Board of Regents
All rights reserved.

ISBN 978-0-8165-1113-6 (paper)

Library of Congress Cataloging in Publication Data
Name: Harjo, Joy, author. | Strom, Stephen E., photographer
Title: Secrets from the center of the world / Joy Harjo ; photographs by Stephen Strom
Description: Tucson : The University of Arizona Press, 2019. | Originally published in 1989. p. cm.—(Sun tracks; v. 17)
Identifiers: LCCN 89004664 | ISBN 9780816511136 (pbk. : alk. paper)
Subjects: 1. Navajo Indians—Poetry. 2. Navajo Indians—Pictorial works. 3. Arizona—Poetry. 4. Arizona—Description and travel—Views.
Classification: LCC PS501 .S85 vol. 17 PS3558.A62423 | DDC [811'.54] 89-4664 810'.8s—dc19 | LC record available at https://lccn.loc.gov/89004664

Printed in the United States of America
♾ This paper meets the requirements of ANSI/NISO Z39.48–1992 (Permanence of Paper).

British Cataloguing-in-Publication Data
A catalogue record for this book is available from the British Library.

PREFACE

All landscapes have a history, much the same as people exist within cultures, even tribes. There are distinct voices, languages that belong to particular areas. There are voices inside rocks, shallow washes, shifting skies; they are not silent. And there is movement, not always the violent motion of earthquakes associated with the earth's motion or the steady unseen swirl through the heavens, but other motion, subtle, unseen, like breathing. A motion, a sound, that if you allow your own inner workings to stop long enough, moves into the place inside you that mirrors a similar landscape; you too can see it, feel it, hear it, know it.

Stephen Strom's photographs lead you to that place. The camera eye becomes a space you can move through into the powerful landscapes that he photographs. The horizon may shift and change around you, but underneath it is the heart from which we move.

From the mud hills of Nazlini to Moencopi Rise, on the other side of Tuba City, the earth Strom photographs speaks powerful stories. They are of its own origins as the keeper of bones; of survival; of the travels and changes of the people moving on it, inside it; of skies. And the stories change with light, with what is spoken, with what is lived.

You can look at the photograph called "White Mesa Overlook" and know something of the way the land speaks, of the way the Navajo people respond to it. There is something about the way the settlement of people is arranged that is internal, that comes out of the landscape. Strom's extremely fine depth of field emphasizes this. The distances he imitates make sense in terms of tribal vision. We feel how it all flows together, and time takes on an expansive, mythical sense.

Strom's photographs emphasize the "not-separate" that is within and that moves harmoniously upon the landscape. The camera is used to see with a circular viewpoint which becomes apparent even though the borders of the images remain rectangular. The land in these photographs is a beautiful force, in the way the Navajo mean the word "beautiful," an all-encompassing word, like those for

land and sky, that has to do with living well, dreaming well, in a way that is complementary to all life.

The photographs are not separate from the land, or larger than it. Rather they gracefully and respectfully exist inside it. Breathe with it. The world is not static but inside a field that vibrates. The whole earth vibrates. Stephen Strom knows this, sees this, and successfully helps us to remember.

SECRETS FROM THE CENTER OF THE WORLD

My house is the red earth; it could be the center of the world. I've heard New York, Paris, or Tokyo called the center of the world, but I say it is magnificently humble. You could drive by and miss it. Radio waves can obscure it. Words cannot construct it, for there are some sounds left to sacred wordless form. For instance, that fool crow, picking through trash near the corral, understands the center of the world as greasy scraps of fat. Just ask him. He doesn't have to say that the earth has turned scarlet through fierce belief, after centuries of heartbreak and laughter—he perches on the blue bowl of the sky, and laughs.

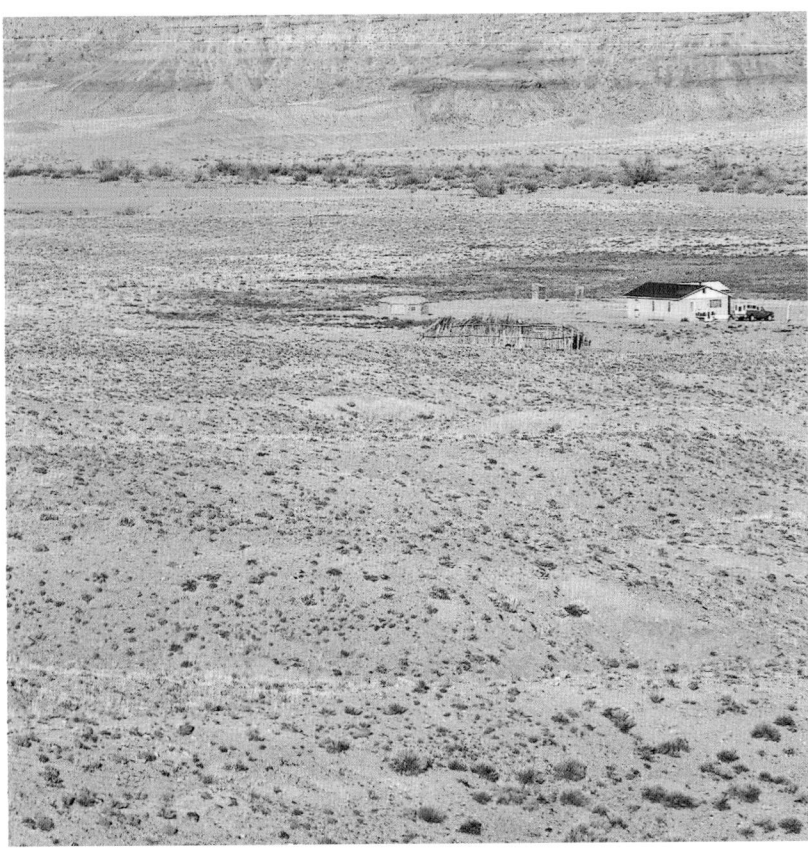

If you look with the mind of the swirling earth near Shiprock you become the land, beautiful. And understand how three crows at the edge of the highway, laughing, become three crows at the edge of the world, laughing.

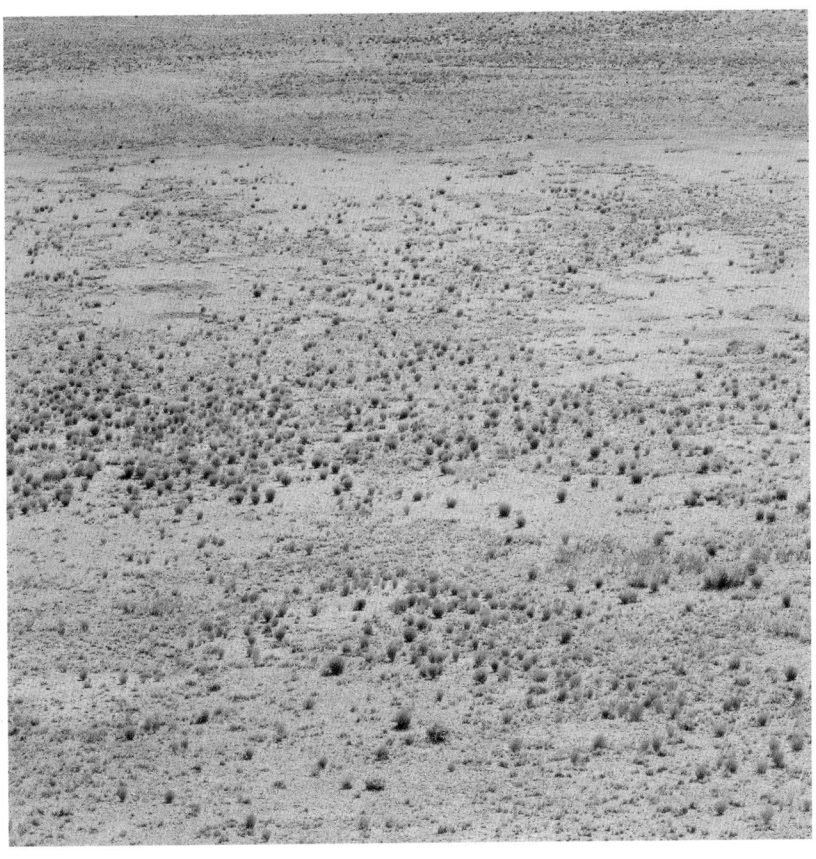

Near Round Rock is a point of balance between two red stars. Here you may enter galactic memory, disguised as a whirlpool of sand, and discover you are pure event mixed with water, occurring in time and space, as sheep, a few goats, graze, keep watch nearby.

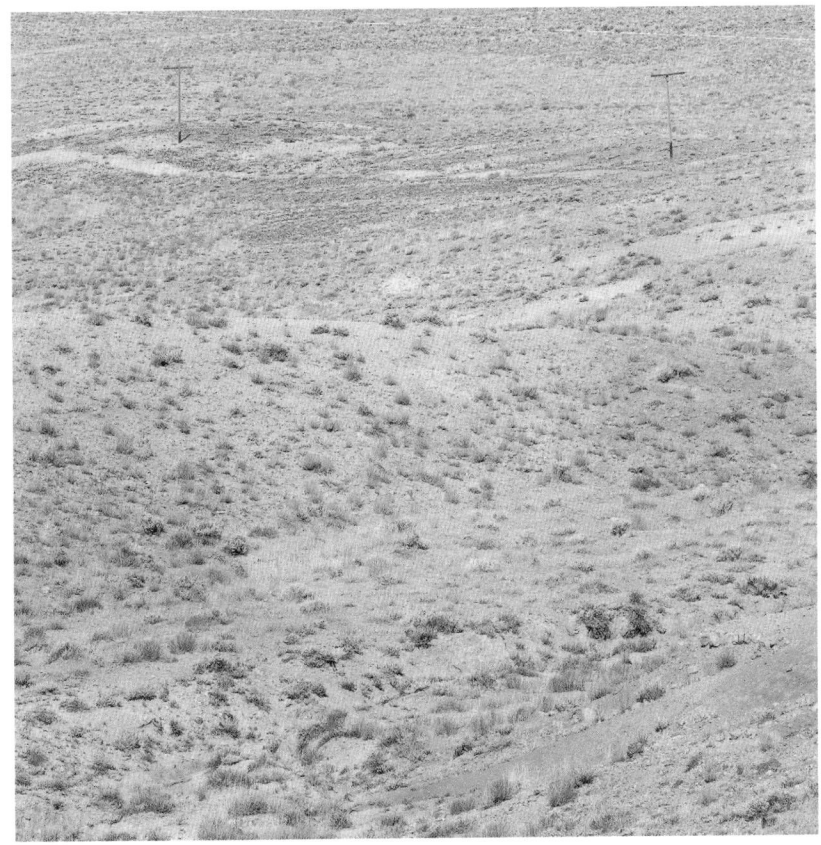

I don't imagine the turquoise bracelet the dusky wash makes, or the red hills circling the dreaming eye of this sacred land. I don't imagine anything but the bracelet around my wrist, the red scarf around my neck as I urge my pretty horse home.

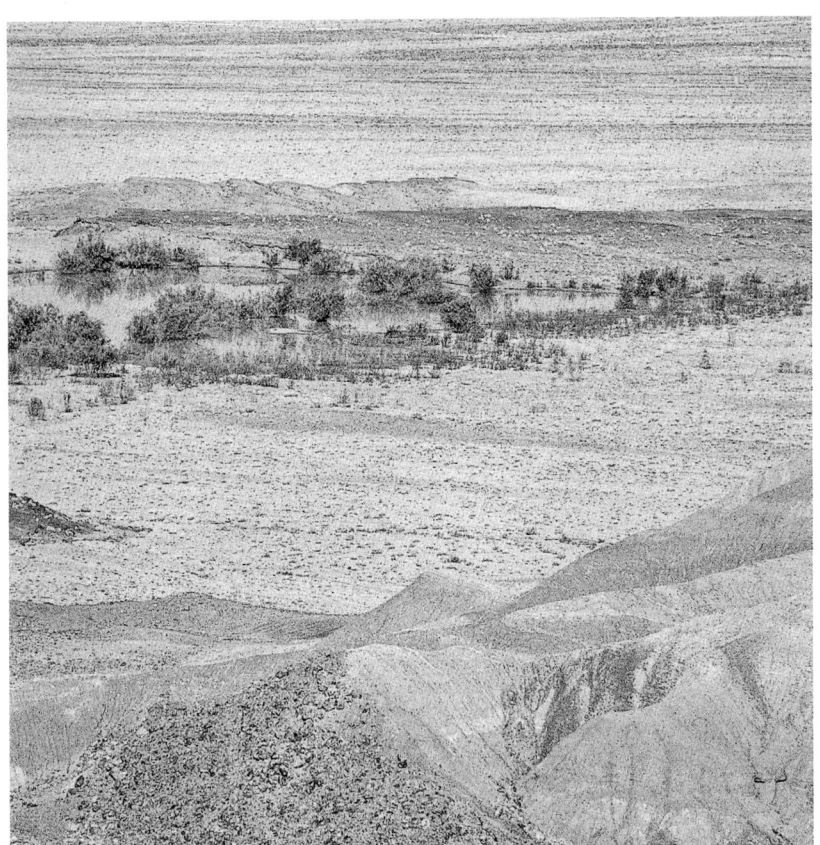

If all events are related, then what story does a volcano erupting in Hawaii, the birth of a woman's second son near Gallup, and this shoulderbone of earth made of a mythic monster's anger construct? Nearby a meteor crashes. Someone invents aerodynamics, makes wings. The answer is like rushing wind: simple faith.

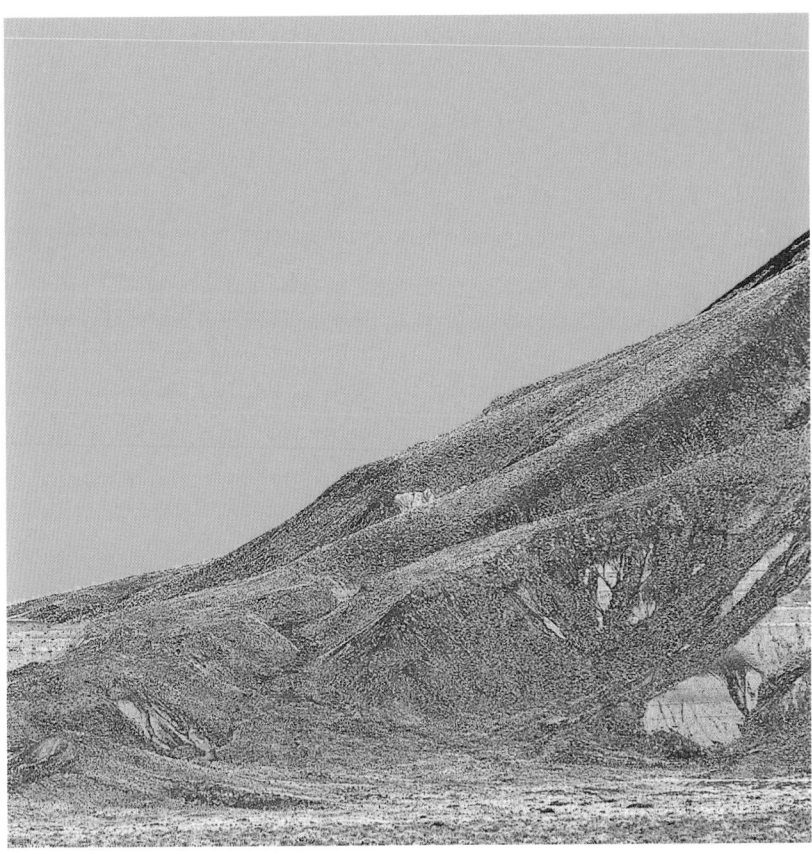

Moencopi Rise stuns me into perfect relationship, as I feed a skinny black dog the rest of my crackers, drink coffee, contemplate the frozen memory of stones. Nearby are the footprints of dinosaurs, climbing toward the next century.

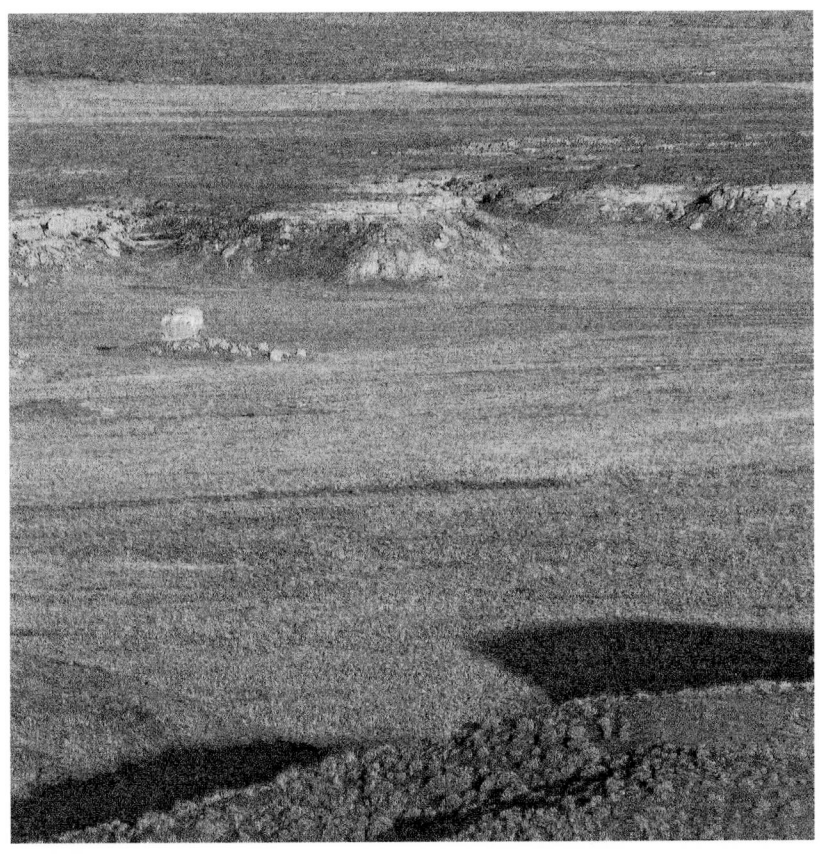

In a misty dawn at the center of the world is the morning star, tending cattle at the other side of this fence. Several years away you can see smoke from a hogan where an old man is cooking breakfast. He has already been outside to pray, recognized the morning star and his relationship to it, as he stands at the center of miracles.

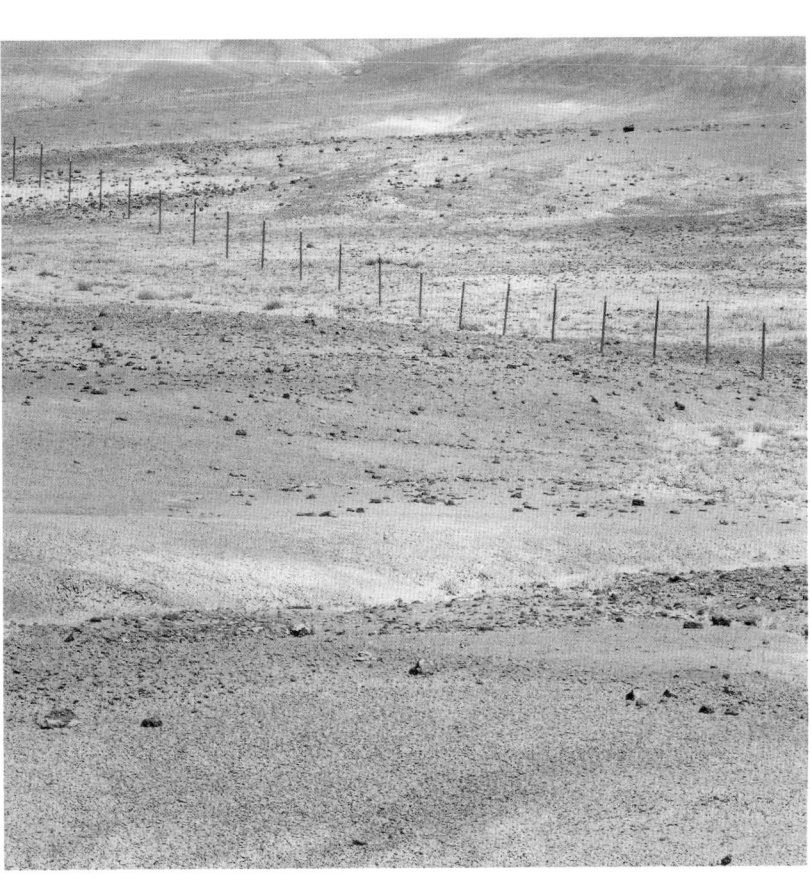

Near Shiprock five horses stand at the left side of the road, watching traffic. A pole carrying talk cuts through the middle of the world. They notice the smoking destruction from the Four Corners plant as it veers overhead, shake their heads at the ways of these thoughtless humans, lope toward the vortex of circling sands where a pattern for survival is fiercely stated.

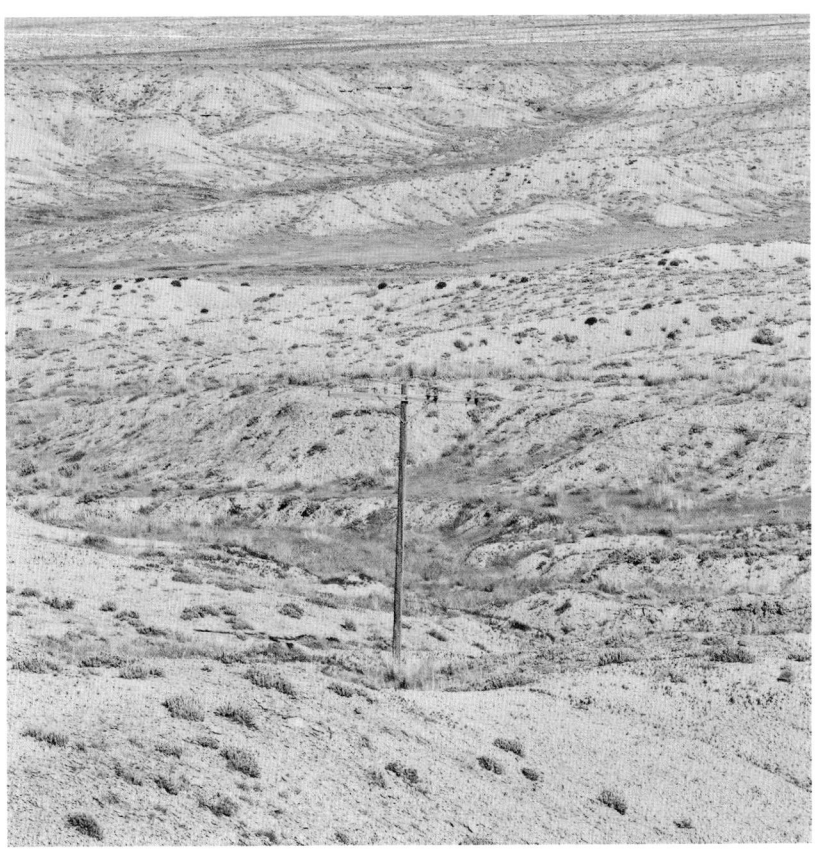

A summer storm reveals the dreaming place of bears. But you cannot see their shaggy dreams of fish and berries, any land signs supporting evidence of bears, or any bears at all. What is revealed in the soaked rich earth, forked waters, and fence line shared with patient stones is the possibility of everything you can't see.

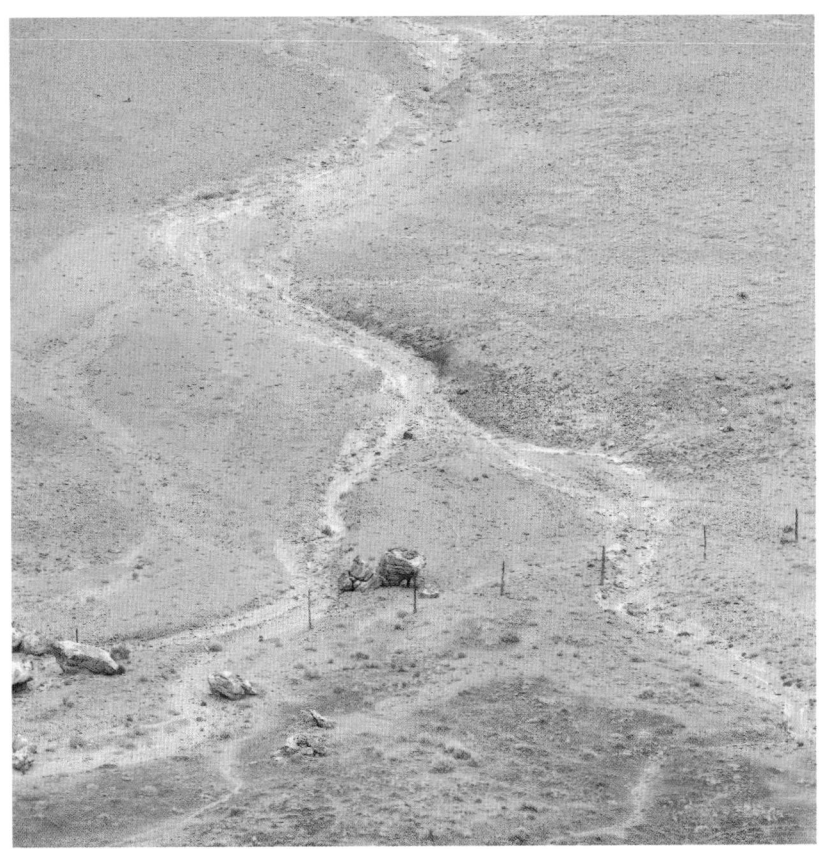

These tamaracks pretend to be tamaracks and they do it better than anything. But maybe they have you fooled, for they could be crows, leaning over the edge of the world, tasting the wind blown up from a pool of newly born planets.

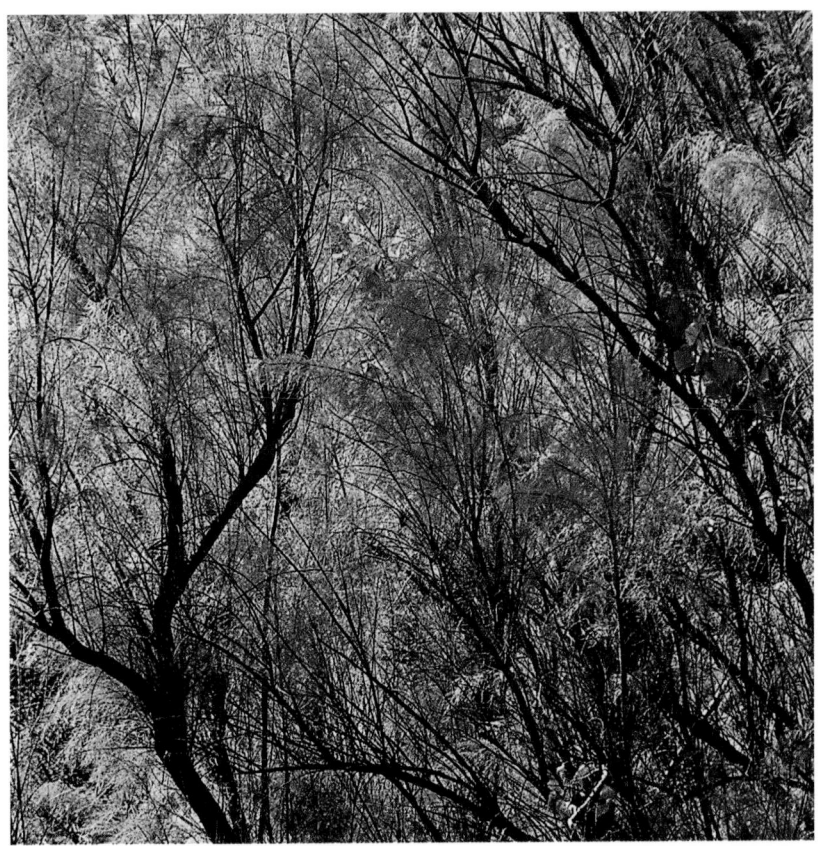

It's true the landscape forms the mind. If I stand here long enough I'll learn how to sing. None of that country & western heartbreak stuff, or operatic duels, but something cool as the blues, or close to the sound of a Navajo woman singing early in the morning.

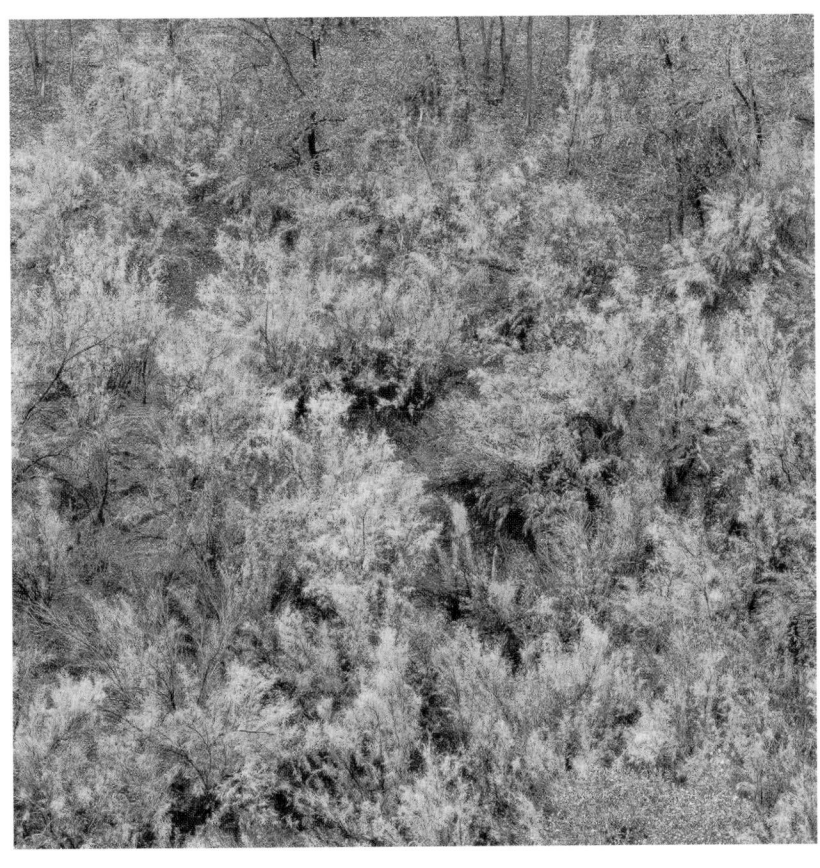

Stories are our wealth. Winter nights we tell them over and over. Once a star fell from the sky, but it wasn't just any star, just as this isn't just any ordinary place. That cedar tree marks the event and the land remembers the flash of its death flight. To describe anything in winter whether it occurs in the past or the future requires a denser language, one thick with the promise of new lambs, heavy with the weight of corn milk.

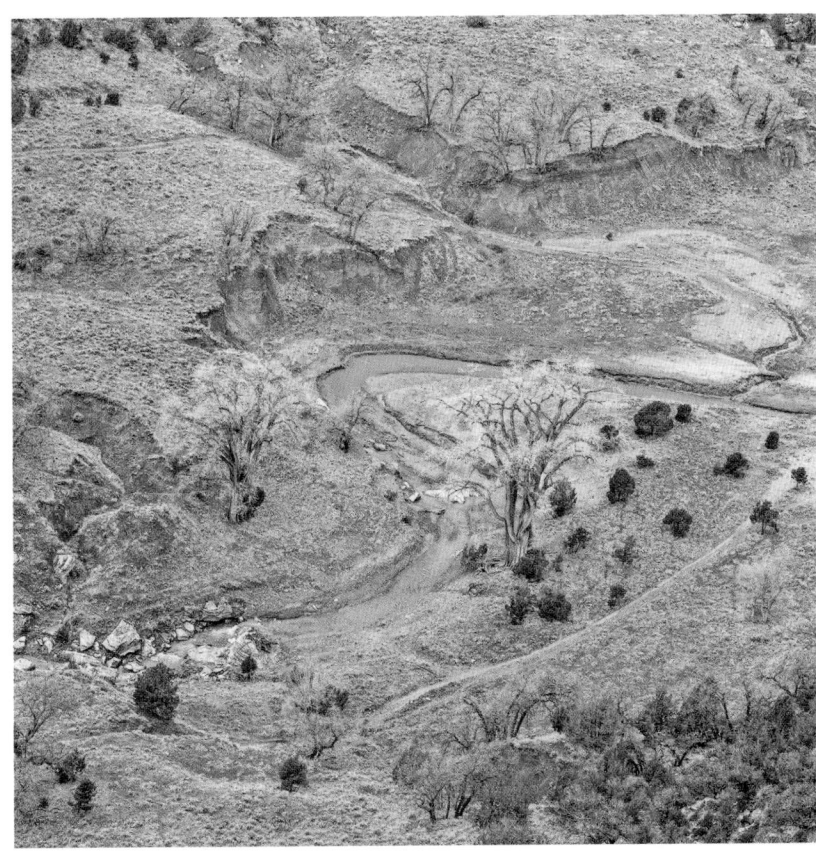

If winter describes the frozen angles of this sandy wash, then how can I see summer arriving in the distance, the sun with its arms on our shoulders? Maybe it is your laugh that calls close hot memory. We all laughed and sang all night, watched the sun overtake the earth in sweetness. Do you remember the song that Oklahoma girl taught us?

> When the dance is over, sweetheart,
> I will take you home
> in my one-eyed Ford . . .

Did we ever make it home?

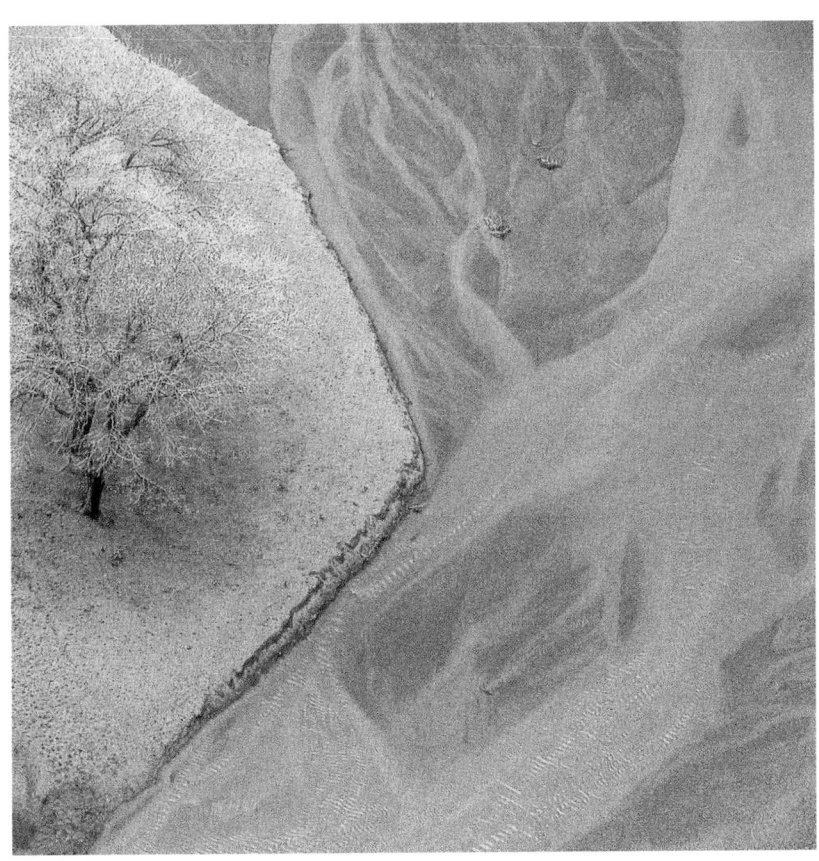

Scarlet bluffs gather here to drink and watch deer trip down in dusk. Everything arrives perfectly in time, including snow clouds that bless the earth. And the moon, the blind eye of an ancient mountain lion who shifts his bones on a starry branch.

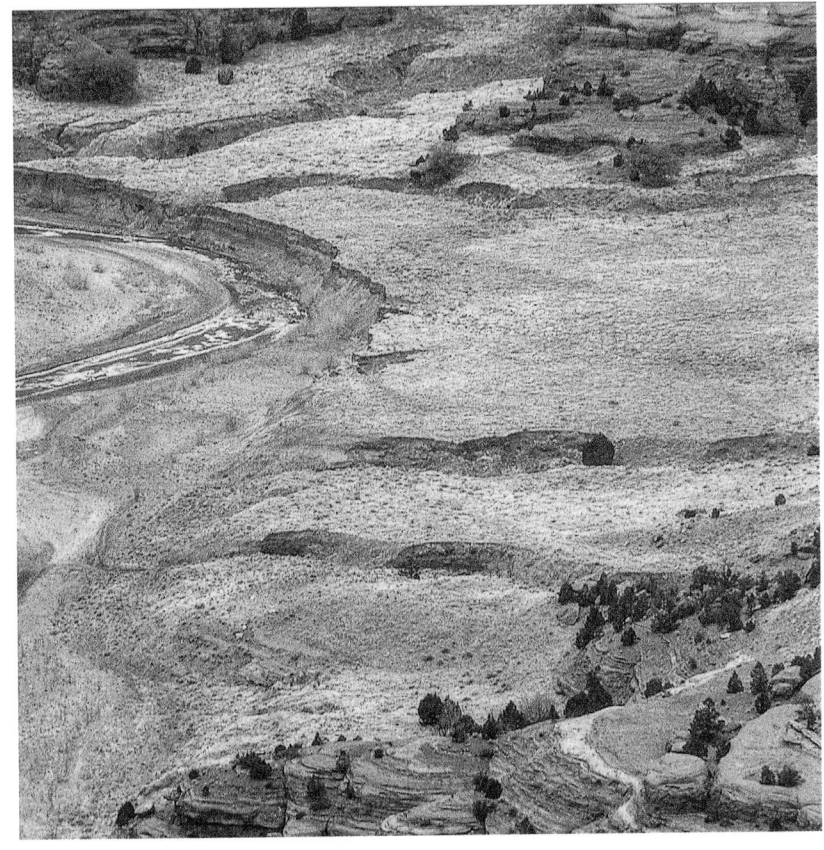

This land is a poem of ochre and burnt sand I could never write, unless paper were the sacrament of sky, and ink the broken line of wild horses staggering the horizon several miles away. Even then, does anything written ever matter to the earth, wind, and sky?

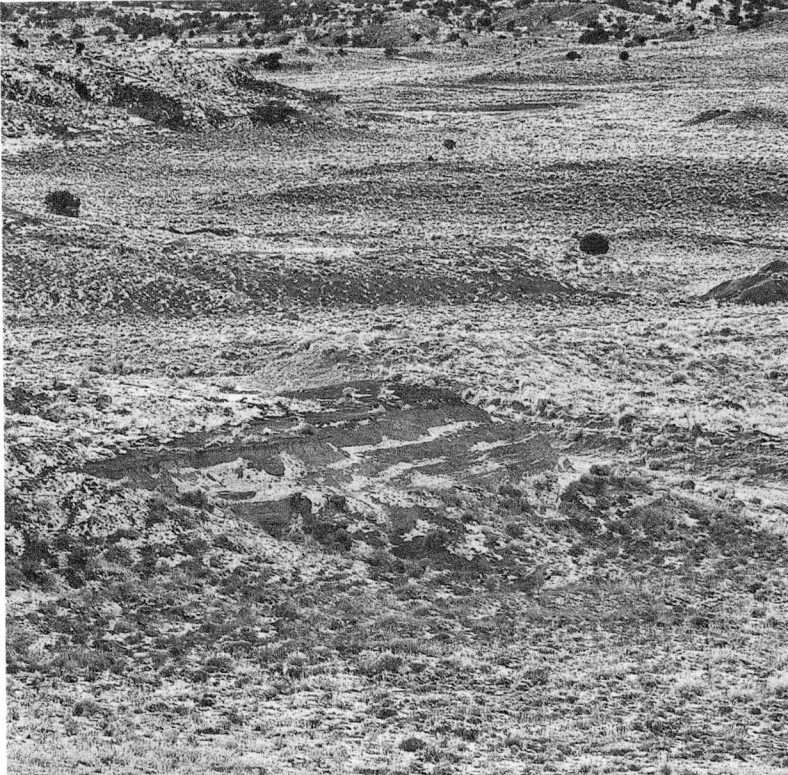

Anything that matters is here. Anything that will continue to matter in the next several thousand years will continue to be here. Approaching in the distance is the child you were some years ago. See her laughing as she chases a white butterfly.

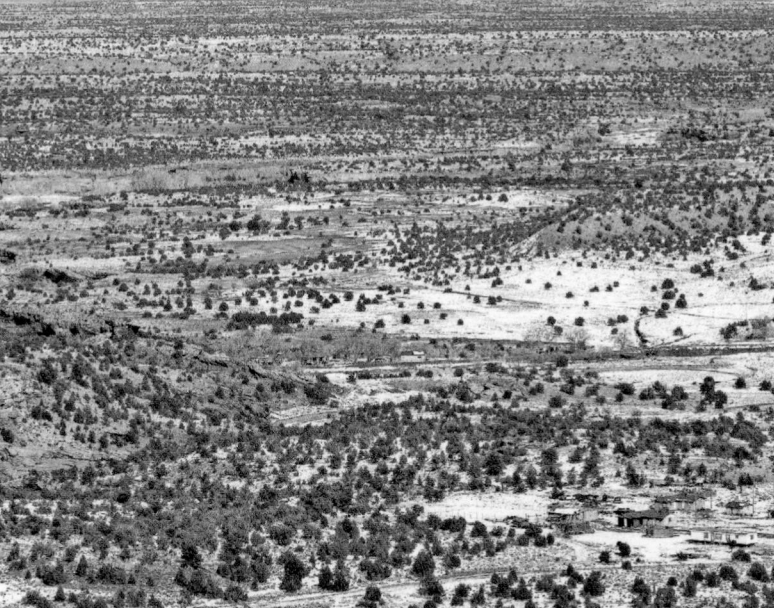

In winter it is easier to see what my death might look like, over there, disappearing into the misty, spotted rocks.

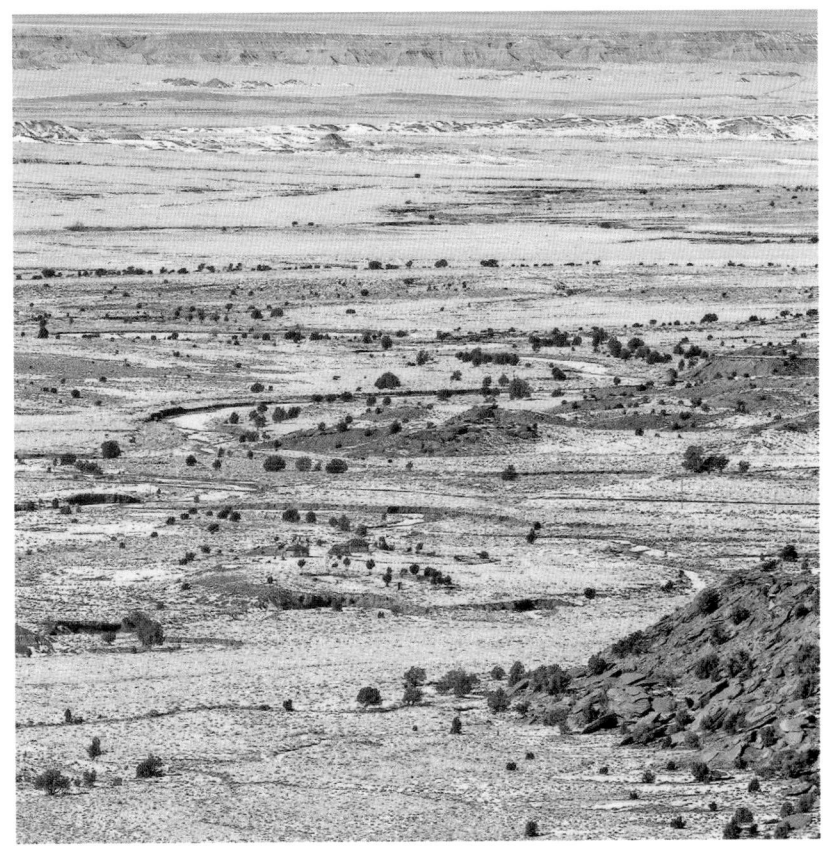

And in the season of new grass my birth is more visible, in the young lambs playing beside their mothers, in the gleam of prophetic stars and the iridescent blur of dragonflies that fly between heaven and hell.

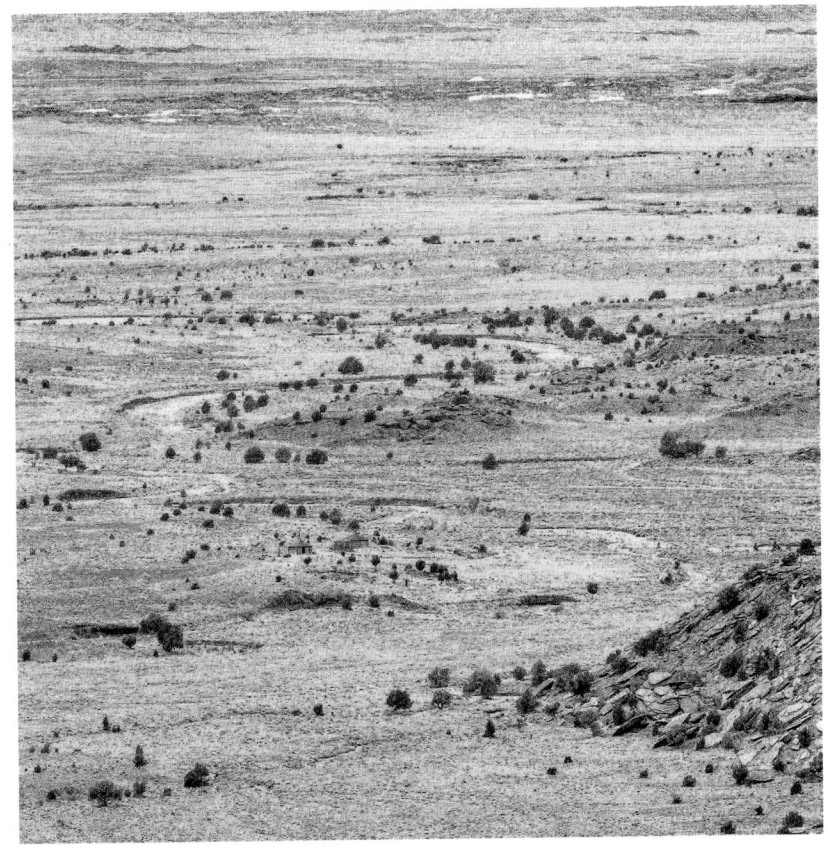

I discover where giant butterflies burrow and dream. Startle them. They rise in unison, become the sky by imagining rainbows. They are shimmering power in the wet light in this valley they call Beautiful.

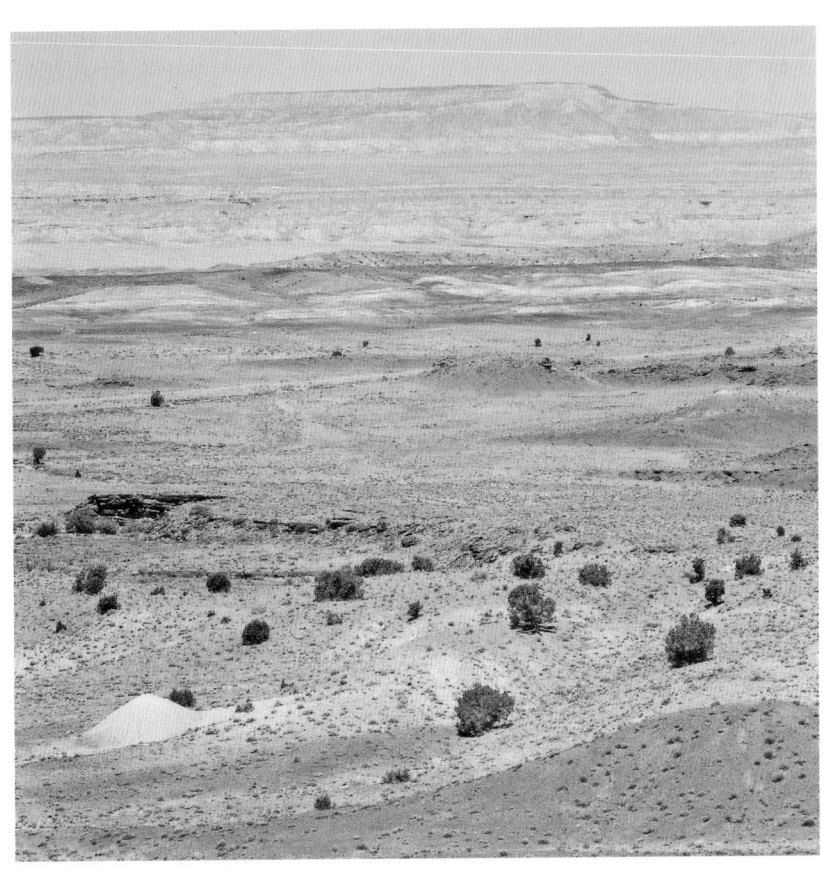

I see the flash of silver breaths on the wing of the sky, and hear the explosion of a thousand horses running. We are rich in this place of many horses.

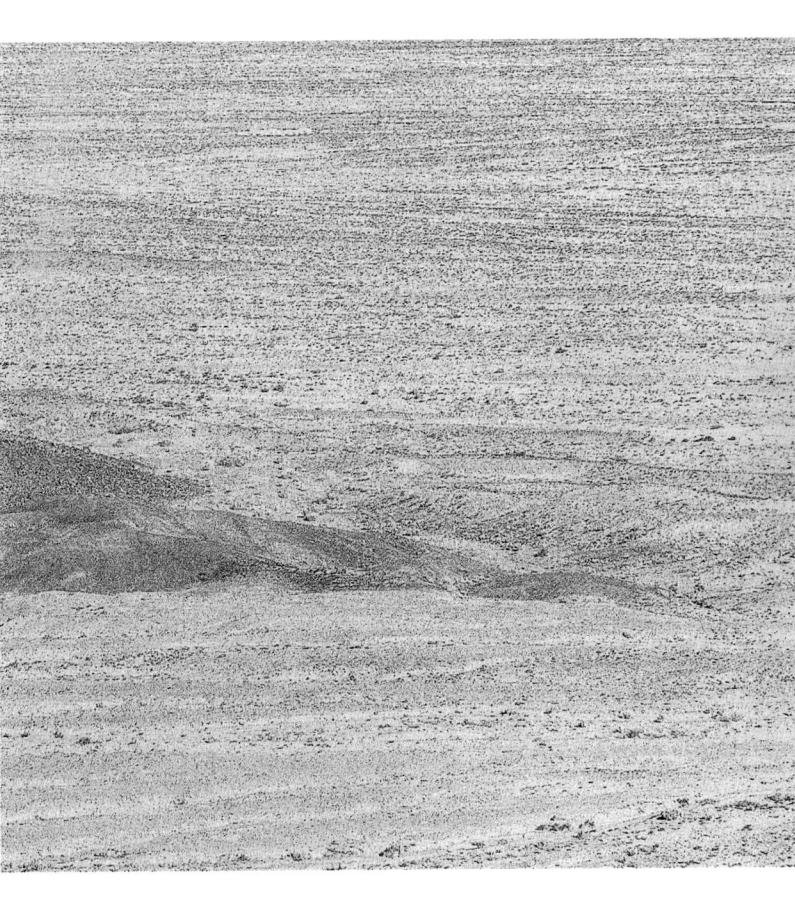

Two sisters meet on horseback. They gossip: a cousin eloped with someone's husband, twins were born to his wife. One is headed toward Tsaile, and the other to Round Rock. Their horses are rose sand, with manes of ashy rock.

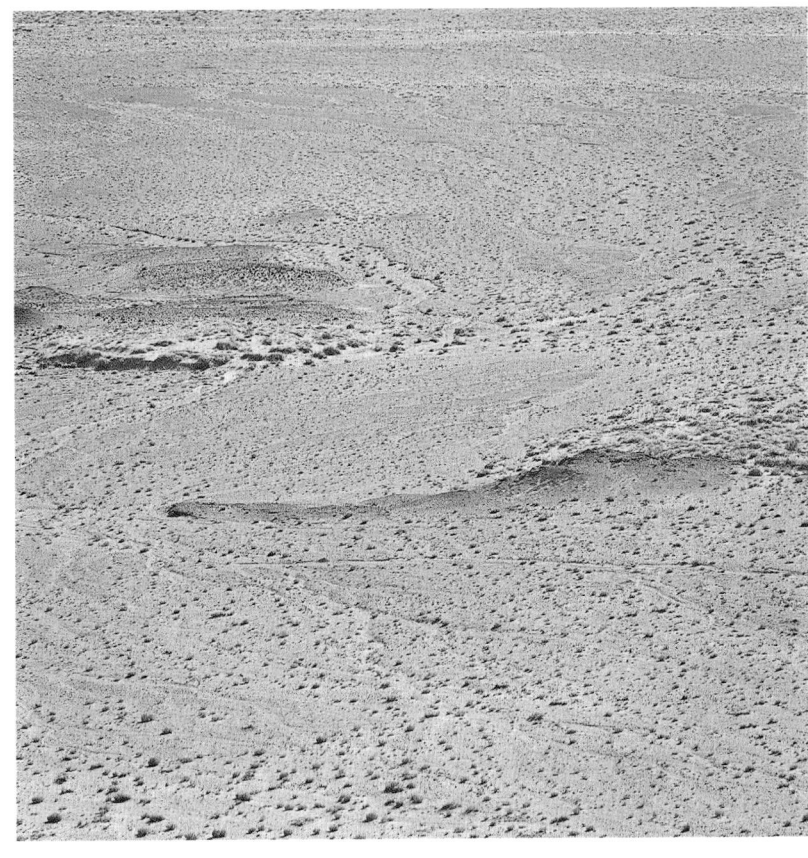

These smoky bluffs are old traveling companions, making their way through millennia. Ask them if you want to know about the true turning of history. You'll have to offer them something more than one good story, and need to understand the patience of stones.

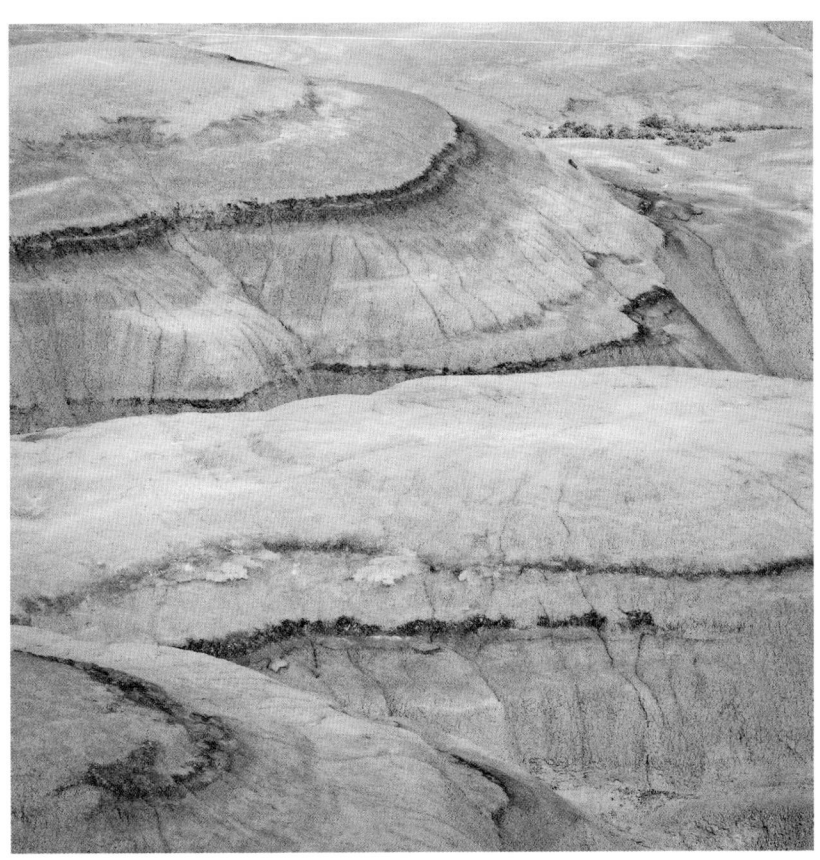

Invisible fish swim this ghost ocean now described by waves of sand, by water-worn rock. Soon the fish will learn to walk. Then humans will come ashore and paint dreams on the drying stone. Then later, much later, the ocean floor will be punctuated by Chevy trucks, carrying the dreamers' descendants, who are going to the store.

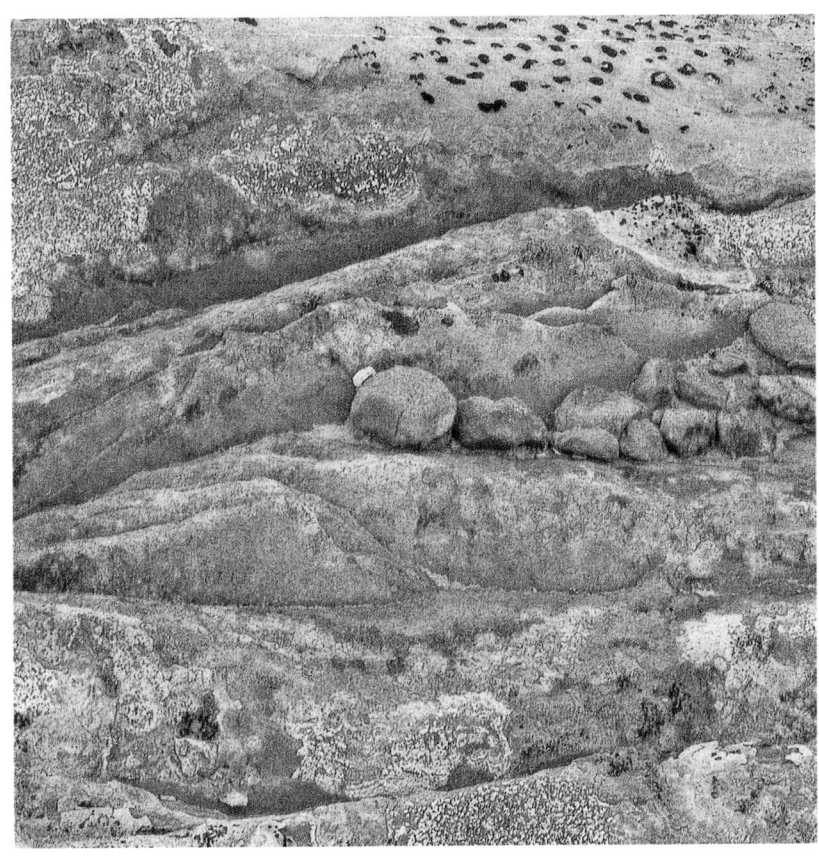

My cheek is flat against memory described by stone and lichen. The center of the world is within reach. It is as familiar as your name, as strange as monsters in your sleep.

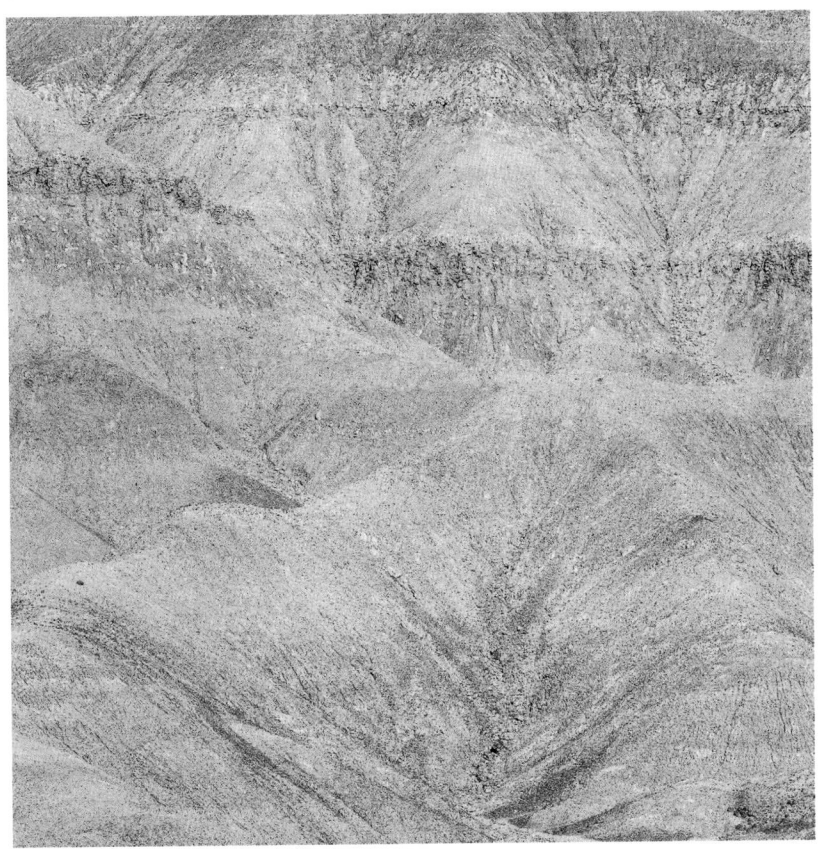

This earth has dreamed me to stand on the rise of this highway, to admire who she has become.

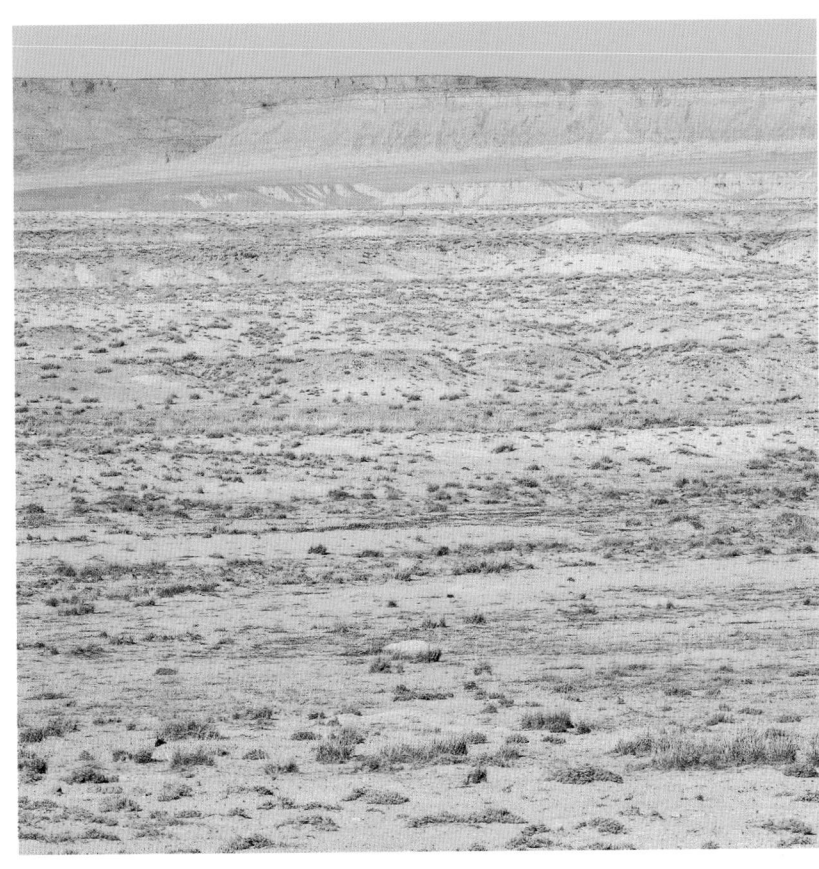

I have lost my way many times in this world, only to return to these rounded, shimmering hills and see myself recreated more beautiful than I could ever believe.

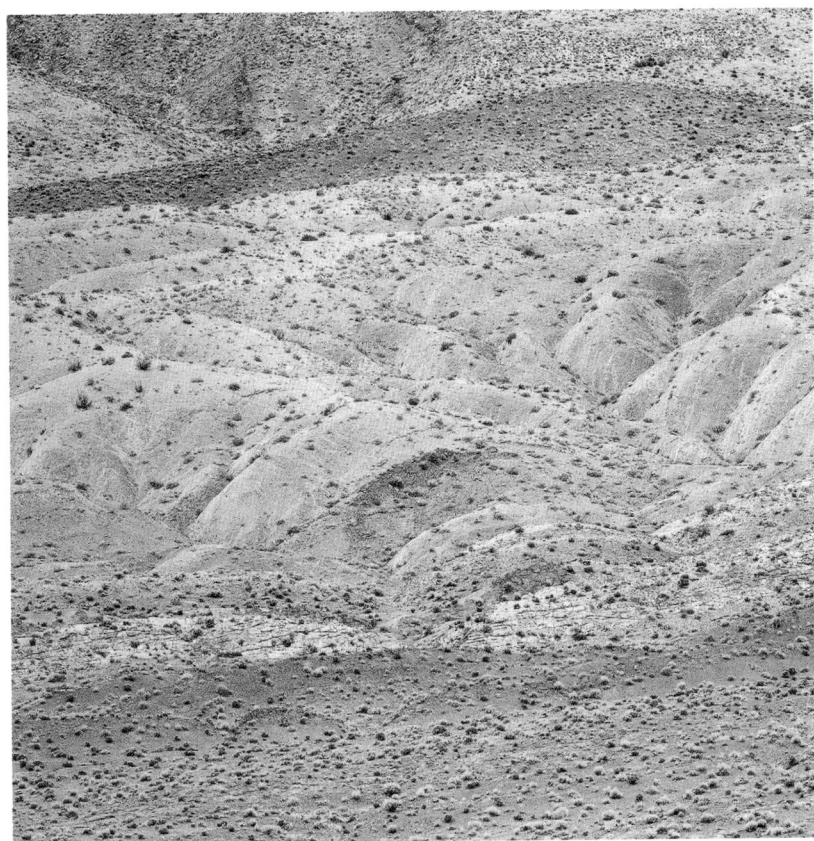

Don't bother the earth spirit who lives here. She is working on a story. It is the oldest story in the world and it is delicate, changing. If she sees you watching she will invite you in for coffee, give you warm bread, and you will be obligated to stay and listen. But this is no ordinary story. You will have to endure earthquakes, lightning, the deaths of all those you love, the most blinding beauty. It's a story so compelling you may never want to leave; this is how she traps you. See that stone finger over there? That is the only one who ever escaped.

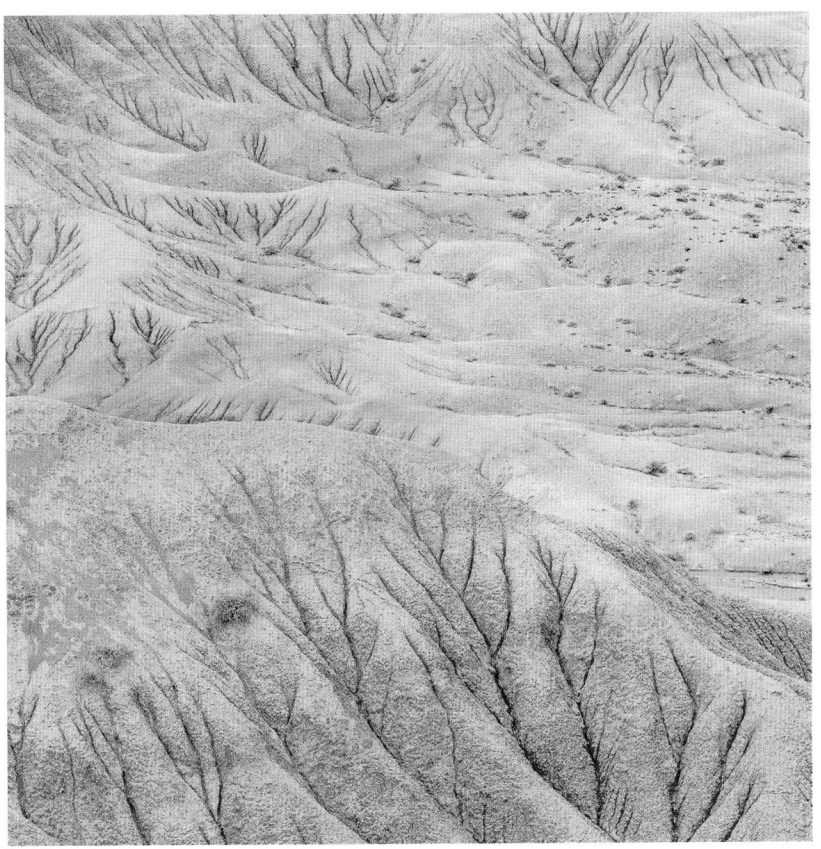

I can hear the sizzle of newborn stars, and know that anything of meaning, of fierce magic is emerging here. I am witness to flexible eternity, the evolving past, and I know we will live forever, as dust or breath in the face of stars, in the shifting pattern of winds.

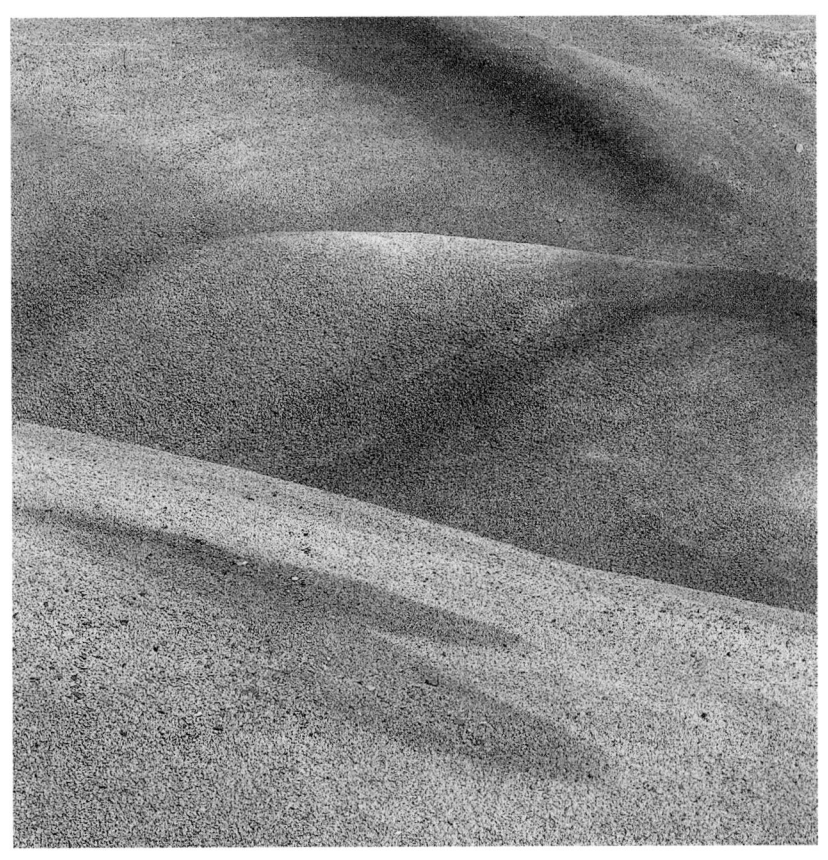

Racing the flamboyant plain of sunset, these rocks are antelope, hurtling toward the edge of the world. I race with them and anticipate that gorgeous leap into knowing everything.

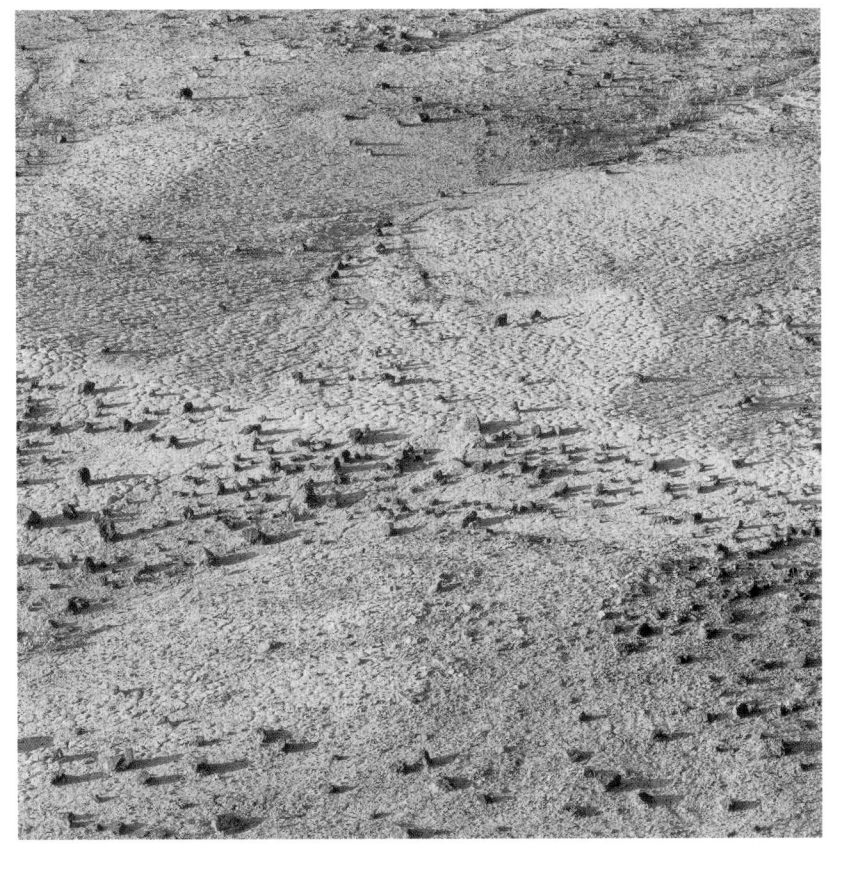

It is an honor to walk where all around me stands an earth house made of scarlet, of jet, of ochre, of white shell. It is more than beautiful at the center of the world.

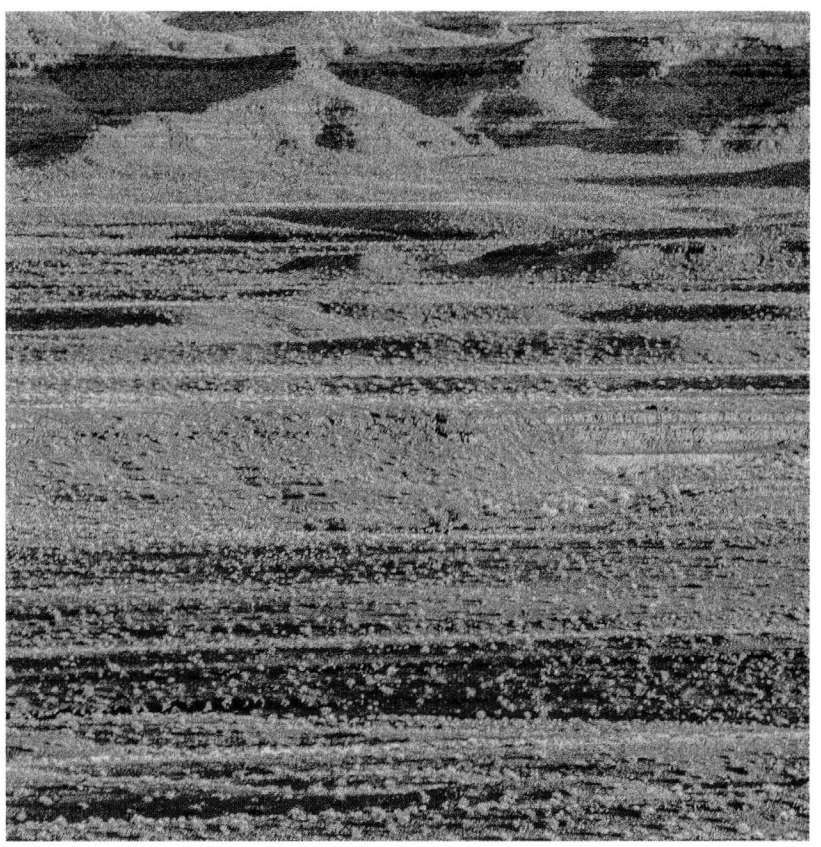

THE PHOTOGRAPHS

ABOUT THE AUTHOR

Joy Harjo, is an enrolled member of the Muscogee Creek Nation. She is the author of eight books of poetry, including her most recent, *An American Sunrise*. She has also published a memoir, *Crazy Brave*, and children's books including *For a Girl Becoming*. She is also a musician and has released four CD's of music including her most recent, *A Trail Beyond Tears*. She is the 23rd U.S. Poet Laureate. She lives in Tulsa, Oklahoma.

ABOUT THE PHOTOGRAPHER

Stephen E. Strom received his PhD in astronomy from Harvard University in 1964, and began photographing in 1978. Strom's photographic work has been exhibited widely in the United States and internationally, and is held in several permanent collections, including those at the Center for Creative Photography in Tucson and the Museum of Fine Arts in Boston. His work has also appeared alongside poems and essays in many published books, including most recently *Bears Ears: Views from a Sacred Land* and *Voices from Bears Ears: Seeking Common Ground on Sacred Land.* He lives in Sonoita, Arizona, southeast of Tucson.